CW00540024

crooked

crooked

words and music by
kristin hersh

photographs by
lisa fletcher

The Friday Project
An imprint of HarperCollinsPublishers
77–85 Fulham Palace Road
Hammersmith, London W6 8JB
www.harpercollins.co.uk

Love this book? www.bookarmy.com

First published by The Friday Project in 2010
Copyright © Kristin Hersh 2010

1

Kristin Hersh asserts the moral right to
be identified as the author of this work

A catalogue record for this book
is available from the British Library

978-0-00-737186-0

Typeset by Jesse von Doom

Printed and bound in Hong Kong by
Printing Express Ltd.

This record is dedicated to
the memory of Vic Chesnutt & to the mighty Finlay Freeman

To unlock your free digital content including:

The full *Crooked* album
Track by track audio commentary by Kristin
Full recording stems for each track allowing you to remix them
Exclusive video content
A forum for you to interract with Kristin
Sample pages from Kristin's memoir *Paradoxical Undressing*

visit

http://kristinhersh.cashmusic.org/crooked/

Where you will find full instructions.

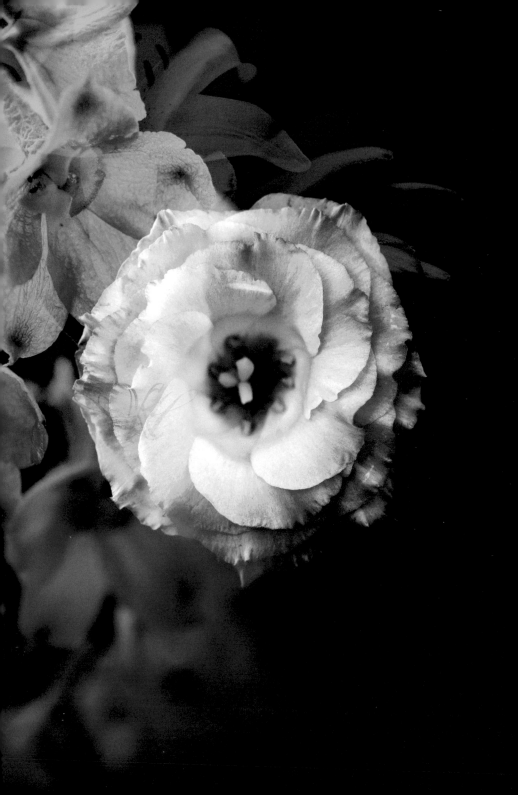

mississippi kite
moan
sand
glass
fortune

01. mississippi kite

"there's always something there to hold your gaze"

Confusion, yeah, but the ranting kind; sort of spinning out. Mississippi Kite doesn't stop to brood over question marks, it blathers and chatters and lists and spits and paces — won't shut up — but ends up saying only that something's missing. Gliding over a gaping hole, squawking.

It's probably true that pretend TVs and LA gloss'll burn you cold. I've had worse, but...cold as a demeanor, no matter what the cause, is limiting. It stops you in your tracks and then you have to live there, safe and sleepy. Not dead, just deadened. Humming along like a zombie.

Singeing your nuts in icy water is better, 'cause that wakes you up. Sure, it's dangerous here, but not caring keeps you from taking care of each *other*. You gotta dole out the snow and lemon drops; that's why you're here.

On fire, underwater, wherever you are, your people are waiting for you to care. Their investment floats you back up to the surface.

Where, of course, you can't help but paddle around a little and glance over at the shore. And there's always something there to hold your gaze.

you paint your own tv on the wall
carve out insects to feed us all
lights flash by and the fast world echoes your thoughts

your compass led you to the edge of a lake
you'll singe your nuts down there if you take
such bad advice from the love gods of hate
you'll get cold

you get burned, you get cold

on the plush green rug in the lime green light
eyes like white stones in black light
i promise you everything that you like

i go "mississippi kite"

gloss assails us then dims
comic book nights, la grim
the hollywood martians, lucky stiffs, fucking win

you told me enough times you can't give me enough rope
to hang myself one time, but i can always hope
you come down on me so hard that i choke and go

you get burned, you get cold

meanwhile, i feed you boric acid and air
lemon drops, snow cream, speckled eggs
the sweat seeps in through a crack in your head

you go "mississippi kite"

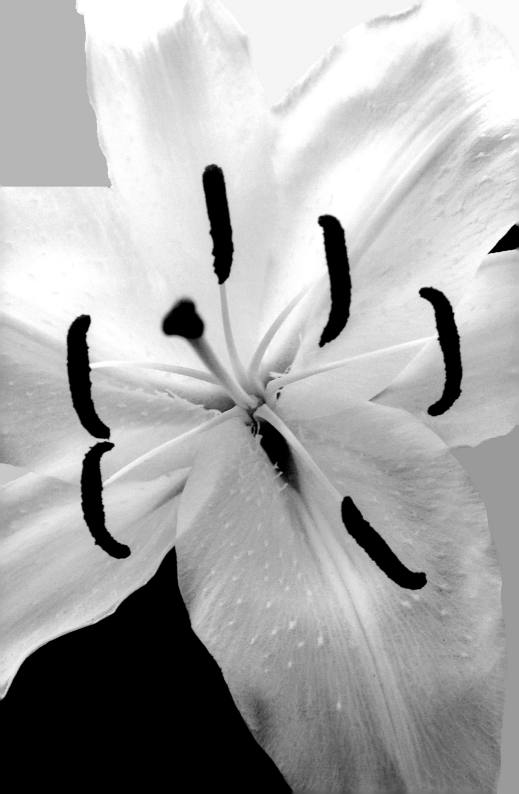

02. moan

"no song is ever convenient"

When I first met Moan, it played for hours. Days, really. I thought it might be a four hour long song, which made me wanna shoot myself. A four hour song'd make *other* people wanna shoot me, too.

But no song is ever convenient. Like kids, songs imagine you have nothing better to do than serve them; not-so-gently suggesting that you refrain from addressing worldly concerns like eating and sleeping and paying the rent until you've given them everything they ask for.

Which is fair, 'cause they only ask for physicality and sociability. Songs need bodies, then they need to walk out into the world and start making friends. And, like children, songs pay us back by telling us what they learned out there in the ether, before we met them.

Right before it lobbed off its own knees — it's now four *minutes*, not four *hours* — Moan told me I should drop my weapons. That was pretty good advice. The ether's smart about weapons; I'm not, particularly. Moan also seems to think that we're messes sometimes and that messes are maybe okay. That's nice to hear, too, 'cause we can be awful heartbreaking. I guess there is something sweet about that.

And I *could* play Moan for hours. So shoot me.

in the deep cold
you can't be brave

in the deep cold
you can't be safe

when the wind blows
you won't be strong

blows with a spine chilling

moan

let's drink to each other
and drink each other half to death

i'm jumping out of my skin
i'm jumping out of my skin again

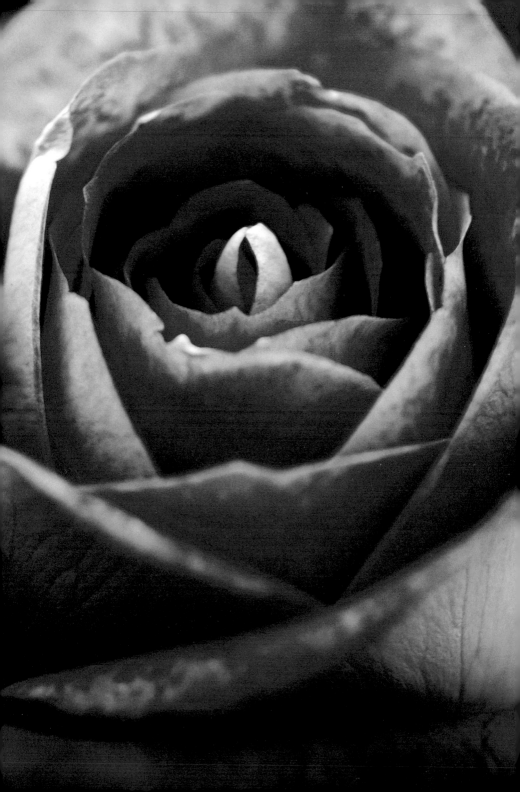

03. sand

"nowhere *is* an appropriate place to be"

Road nature is a meadow behind a dumpster, road health is finding anything to eat, road highs and hangovers are mixed up to the point where you are no longer aware of the contents of your own bloodstream.

Like firefighters, musicians sit and wait and play cards and read books and bullshit and stare out the window, listening to their own breathing, and then sit and wait and stare and shuffle the cards again until suddenly, the fire calls and adrenaline kicks them headfirst into the flames.

I am basically a chicken — a lousy firefighter. Shaky and shy, hyper-aware that there is no longer any time to breathe, I do my best to perform 'cause I'm also scared *not* to, but nothing has ever convinced me that standing on a stage and asking people to look at me is an appropriate thing to do.

When sound happens, though…then I'm not on the stage anymore. I'm nowhere and nowhere *is* an appropriate place to be.

This is, admittedly, a manic depressive lifestyle but if you came on tour with us, you'd see its okayness. 'Cause we all eventually hit the Road Wall — you would, too — and that's a good, gentle, softening thing. That's when your unbuckled brain forces you to peel off wants and see the squirming need beneath, the only one: passion.

This is a luxurious state of mind. It's nowhere. It's home.

race through the country
the perfect carnivore
pull over and stop to breathe
there's grape jelly on your sleeve

you pick me up
i pull you down
down to the ground

make the most of daylight
a sun-drenched meadow by the dumpster
i came back high and hungover
from your flickering light

i hope you find your way home

to the country
the perfect manifested heaven
and stop to breathe
there's an aching heart on your sleeve

you pick me up
i pull you down
down to the ground

your brain unbuckled:
luxurious
and softer than sand

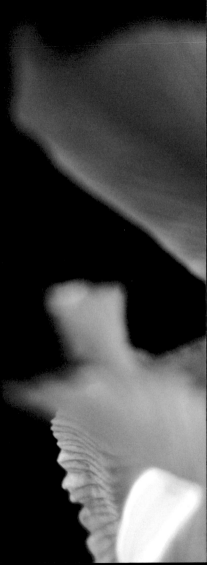

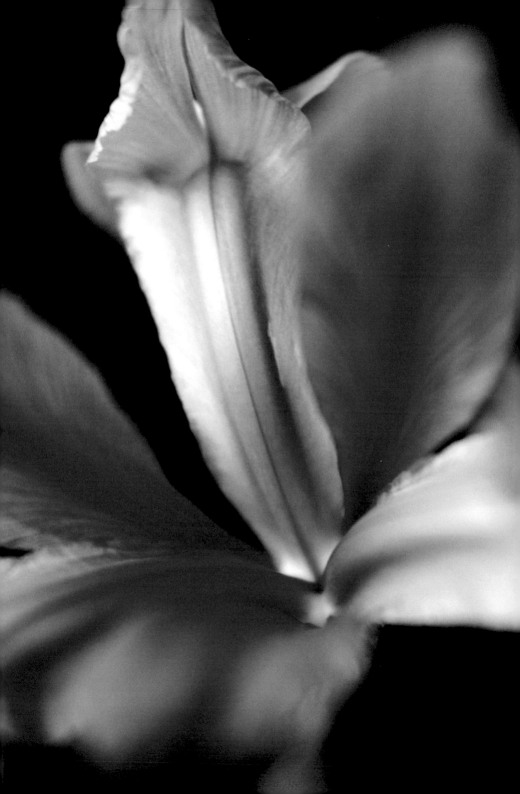

04. glass

"we find ourselves in the dark"

Should glass people be clear or cloudy? I don't know. They *are* lovely. And I know they can't help being see-through. Warily, I let them sleep on the couch in the sunshine and sooner or later, flies are waking up, another spring is here, and it's time to open the windows again. Then I can smile at a glass houseguest's confusing clarity with my *whole* face.

I don't know anybody who wants to see *everything*. Not all the time, anyway. 'Cause a whole lot of crap out there is unsettling, so we shut our eyes, hoping our dreams and brains make up something better than what's really out there. If a nearby personality begins to disintegrate and show us its component parts, we hope it grows quiet or wanders away — *soon* — before things get uncomfortable. In other words, if opaque begins to glow into translucent, we know transparent can't be far behind, so we lean over, tired, and switch off the lights.

In the dark, though, we find ourselves in the dark. *There's gotta be more than this*, we think, peering out the window uncertainly and groping for the light switch, until we come across some pretty piece of information that'll help us make it through another day. That's when we notice that flies're waking up and wonder if maybe it shouldn't be winter anymore, figuring we better open that goddamn window before darkness moves in again.

The glass face on the couch is still waiting for a real smile, anyway; coming up with one is really the only decent thing to do.

is this witchy?
my thoughts are cloudy
this is weird: my mind is clear

in this hyper-chlorinated pool of humanity
you're very clean

i give up

is this hunger?
i can't remember
this is strange: we're just the same

in this insatiable, unstable subspecies
you're very sweet

i give up

flies woke up confused
sprung to life
and spring all here and everything

sleeping on the kitchen couch
sun everywhere
you're very clear

i give up

why put the light on?
why put the light on at all?

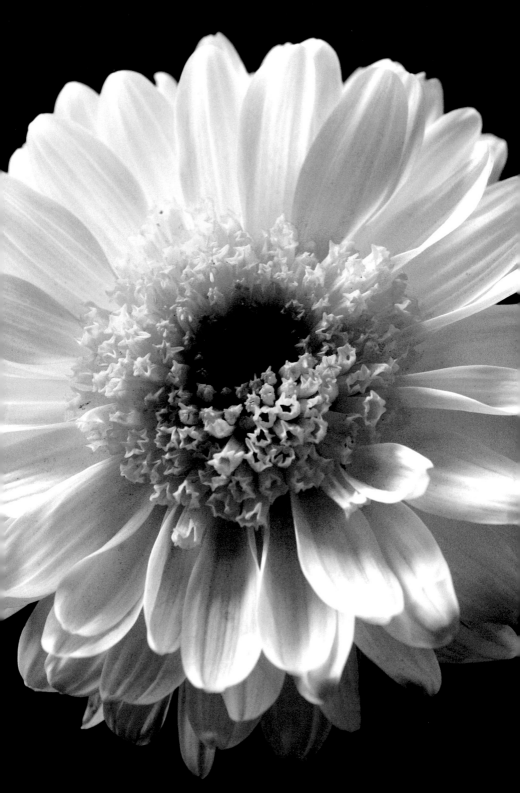

05. fortune

"spacey and distracted,
possibly unhinged"

When Fortune walked into the room, I felt like I'd just met someone interesting but...hard to talk to. Sorta spacey and distracted, possibly unhinged.

Fortune took me back in time a ways, then thrust me into tomorrow, though I didn't know it yet. Spooky. When the future happened, I realized I shoulda been squinting at Fortune when it talked and listening *way* more carefully. Honestly, this song hurts my feelings; I think it's very sad. Cruelly and unusually so.

But Wonder Bread and smoking river devils are both golden and hard to turn away from. Smooth, evil and quintessentially American, they're fascinating in an icky way and they both live comfortably on New York City sidewalks, casting big ol' weird shadows.

But after the cruel unusualness, Fortune just looks over your shoulder and then floats away, of all things. Right before the fatal blow, it pulls back, distracted: *no more hurty words.* Since I don't talk right or understand human speech, when Act Two kicks in with only whale song guitar, Fortune's doing me a favor. Very kind of the handsome devil.

A slap on the face, a kiss on the cheek and then Fortune wanders out of the room, lost in a zone.

i left you cracking up in the east river
like some river devil
both cruel and unusual
thick with gold and smoking

my friend
under the wire again

and by the way
you cost a fortune
and by the way
you cast a shadow today

i watched you crawling up through the leaf litter
you don't seem to need to breathe
unlike us oily, flimsy, cheap
thick with wonder bread

my friend
under the weather again

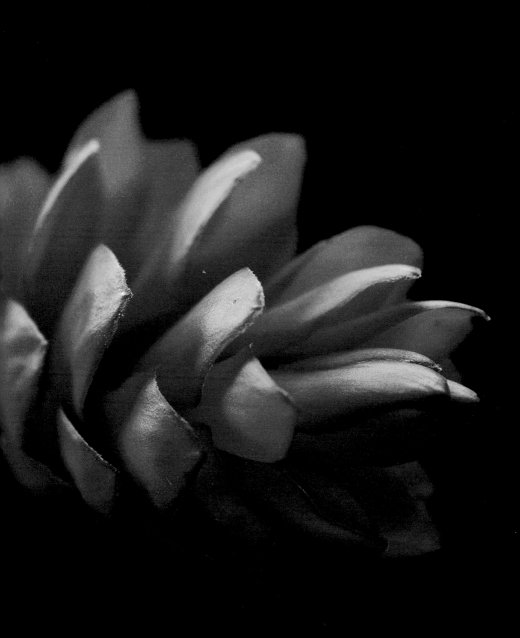

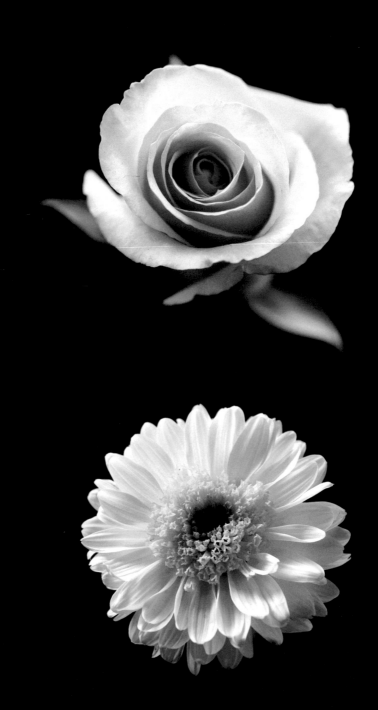

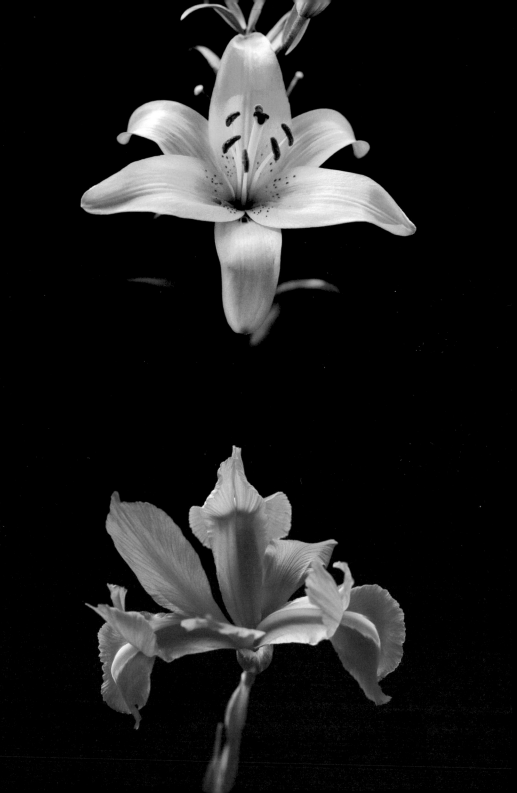

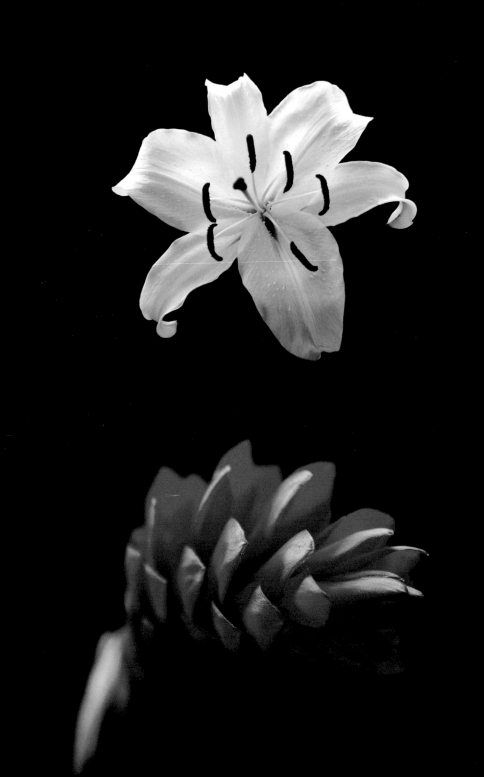

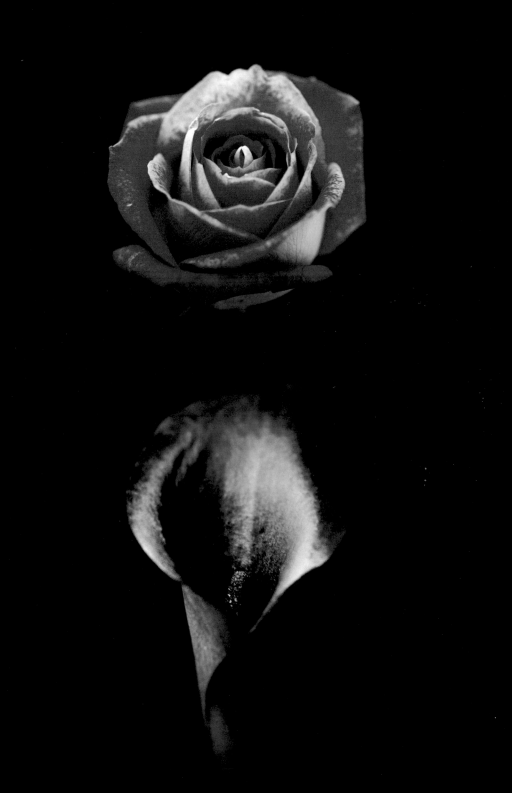

06. coals

"if I only achieve a sliver of Bodhi-ness, I'll be happy"

My son Bodhi, sweet, gentle, contemplative Bodhi, looked up at me over his cereal and said, "Really, I think we should blow stuff up all the *time.*" I nodded 'cause I agree. And 'cause I figure Bodhi's idea of an explosion is a cap gun, a water balloon, the wee-est little mushroom cloud of a vinegar and baking soda volcano.

Humming along feels like stagnation to a six year old and rightly so: *nothing's happening!* But seething coals, quiet little mid-air explosions, just an inch or two off the ground — alive, inanimate happenings pressing into existence — those're wicked cool. No biggie, just...sizzling. As far as explosions go, sizzling's really the only one that's potentially a *lifestyle.*

Sparklers and robots that exhale sparks take on the wretched events that plague us, pitting their shiny muscles against inertia. I know this and yet I have to try really hard not to hover or stagnate. If I only achieve a sliver of Bodhi-ness, I'll be happy. Armed with a water balloon and caps, foaming volcanoes and weird-ass fairy tales...I know his dreams are clean.

shrug off this wretched event
stoic, detached, you relent
you wonder why
we crash but don't land

how a purring engine sputters
like these coals that never cooled
why we crash but don't land

you heated even the mist
around this mossy existence
we never found
cold, gray, calm, dead

it's how a purring engine sputters
like these coals that never cooled
why we crash but don't land

a ramble, a rant
a fairy tale
remorseless and serene

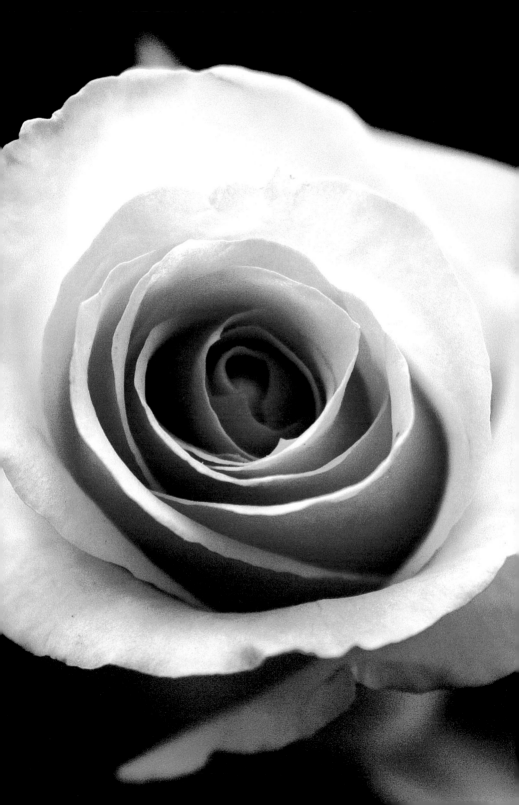

07. crooked

"I'm not trapped in here.
I'm not in here at all."

My Crooked story doesn't matter any more than yours; it's just what got me to the meeting point between myself and this particular song. I imagine that if you adopted this song as your soundtrack for a moment, some of your life pictures would begin to fall into place within its boundaries. That adoption process is the highest honor a songwriter can achieve.

That said, here are my Crooked life pictures:

Last year, an acupuncturist friend in Chicago, said to me, "I can't watch you do this anymore." What she was referring to was bipolar disorder, which makes your insides live an up and down, dark and light, fast and slow, switch-flipping existence. I knew for a fact that it would claim me someday. Then my friend said, "I'm gonna help you whether you like it or not."

I smiled and nodded, which is my response to just about everything anybody says to me, but when this girl stuck needles in my feet, arms, legs, head and face in a San Francisco apartment, I sighed and said, "You don't understand. This is systemic, a world view, a personality. I'm trapped in here."

She smiled and nodded. Then the room spun, my heart pounded, my brain time-tripped, a baseball-sized lump swelled up in my throat and it felt like race cars were driving my outline. But the outline wasn't me — I had an unshakeable "phantom-body" syndrome that wasn't inside my skin — the real me was next to the one made of skin and bones and muscles: a dark, crooked space body. *So, I'm not trapped in here. I'm not in here at all.*

In New York, my friend stuck me with needles on a grimy dressing room couch and then in New England, in a beach house with a winter garden out the window. In New Orleans, when she took her needles to me during a violent thunderstorm, she moved the crooked body into my skin and, in that moment, I swear, saved my life.

hold the flashlight under your chin
closer as the lights dim

you lonely doll
you lucky dog
you free fall
down to the living room
closer as the lights dim

spread the glitter on your pillow
count your blessings on your fingers
crawl your way back down the stairs
down to the living room
closer as the lights dim

glittering
in lazy boys and christmas lights
glittering
then found a dark body
to the right and crooked

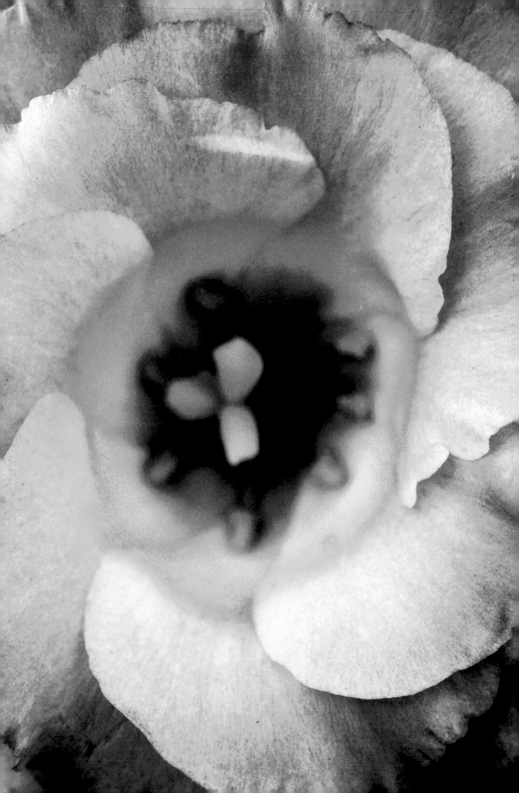

08. krait

"that's what we *do* and it matters"

A Garden of Eden next door to a McDonald's, primordial ooze dripping down the highway, Krait goes humanist biblical on your ass, with a little Raising Arizona thrown in. Which life tends to do too, sometimes. Not a bad way to tear through personhood.

We drive and drive and drive and the road still stretches out before us, an eternity of *going*. That is, until we pull over and find that the dirt is willing to claim us, too.

On the way, fast food and bad air happen...peeling paint. We turn chemicals upside down and backwards, swallow them, breathe them in and *presto!* we got ourselves some messed up brain cells, but maybe...now's the time for messed up brain cells?

Krait's a happy song, though. It keeps going 'cause we keep going; that's what we *do* and it matters. Our children are the crawling, milk-fed ids who don't know broken because, unshakeable in their tiny heroism, they thrust themselves into the battle against wasted time and naked shame, fighting everything that's wrong with us. I read my children as my only Bible 'cause they seem to know *everything*.

And they're so good at picking up where we left off.

in a suburban desert
a fast food high
we swipe at peeling paint
swat away flies

the crawling milk-fed
squawking cream-filled
hominids
ids

immune to broken immune to broken
to wasted time to naked shame
to bolts of lightning to bolts of lightning

bungee together
your body's guards
the bloodiest bond
blacking out the dark

the darkest flame to broken flame
the darkest waltz to broken waltz
a sun burnt snarl to sun burnt snarls
thrashing and parched thrashing and parched

a singular desire
to drive into the dirt
no lust, no gluttony
we're free as algae

those with an all-consuming passion in lockstep

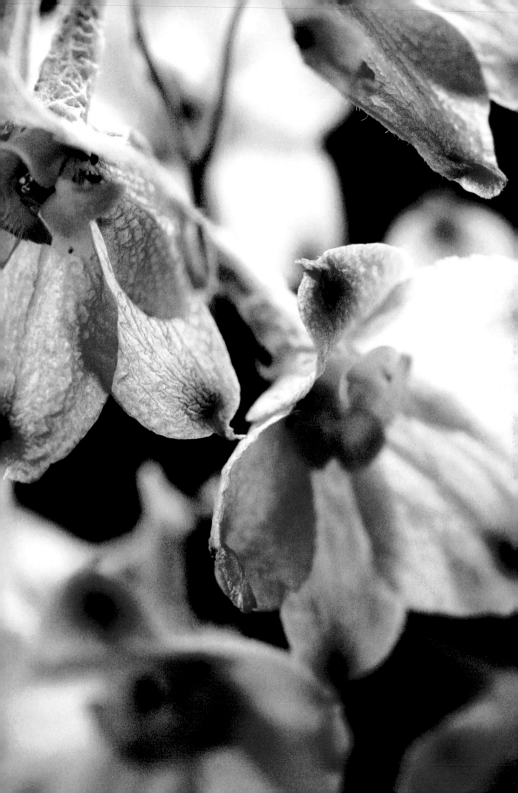

09. flooding

"it *is* sad, I should warn you"

It's okay to slip out of your life clothes and let them fall to the floor. I bet it feels cool.

I don't know. All I know is how it feels to be left behind here on fuzzy, prickly earth. Lost, lousy...sorta pissed off. Essentially bored. I mean like your essence is bored because happy is gone, fun is gone. That metallic glint in your loved one's eye that said, "Something's about to happen" is gone.

Nothing's about to happen is much less exciting, though I imagine it's soothing to the person who left. *No pain is about to happen.* I get that.

So, like most people, when I pick up my head, I grab me a hammer and fashion memory goggles outta that heavy, weightless, left-behind sensation and start telling myself the stories me and the gone person lived together. These stories are the tools that help me work this fuzzy, prickly planet until I'm allowed to slip outta *my* life clothes and follow my friends home.

i can pinpoint the moment you closed your eyes
and said yes to the flooding

like melting you shrugged off the clothes of your life
and, well, i hope you remind me it's here

at twice the speed
hungering
for someone who left in half the time

fuzzy
fumbling
that thirst is gone
we're alone

a parking lot plea
begging
for a future you need

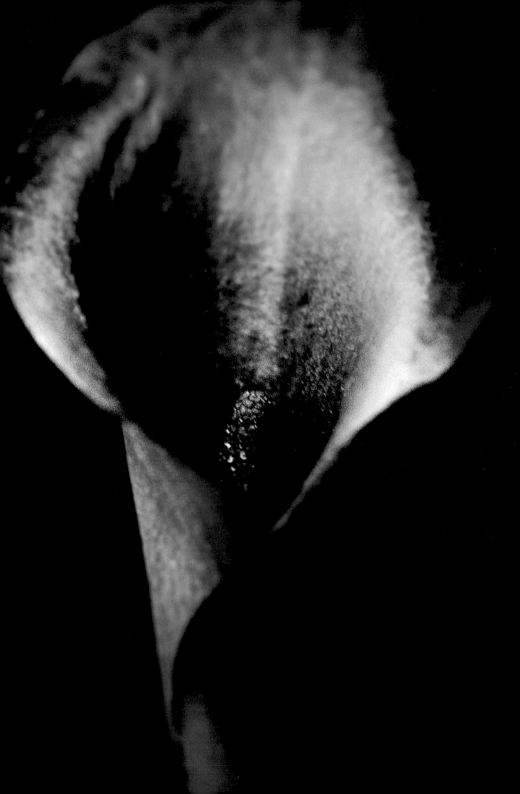

10. rubidoux

"my face ached from laughing"

Rubidoux was written in the back seat of a friend's car somewhere between San Francisco and Los Angeles. It's the only song that's ever come to me *while it was happening*, if that makes any sense.

The song was glowing dark blue just like everything inside the car and out the window, and it clashed ridiculously with the terrible radio the boys up front were dancing to. They were dancing and singing because terrible is so funny. I loved that they could shoo terrible away by dancing with it…

My face ached from laughing that day.

the freeway's freeway close
i laugh from the back
the race is over

headlights on your teeth
race down both your backs
in the dark blue car
a party

blue trash on the floor
i hope you find your hunger
in a hungry world

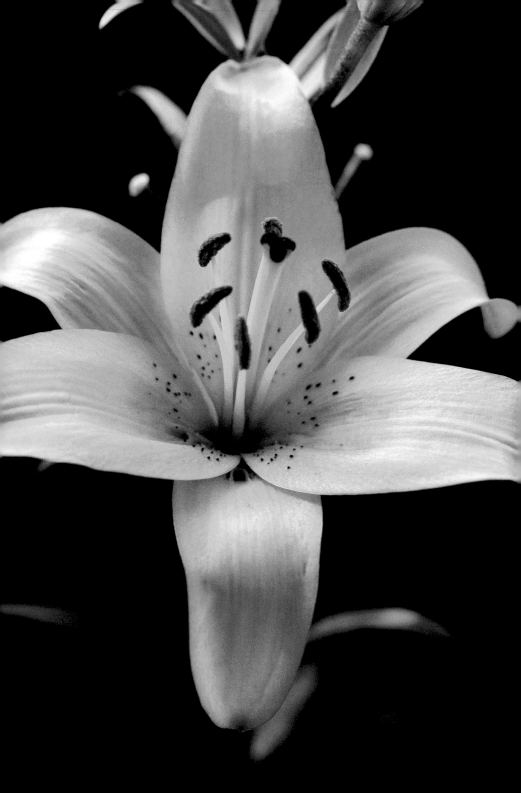

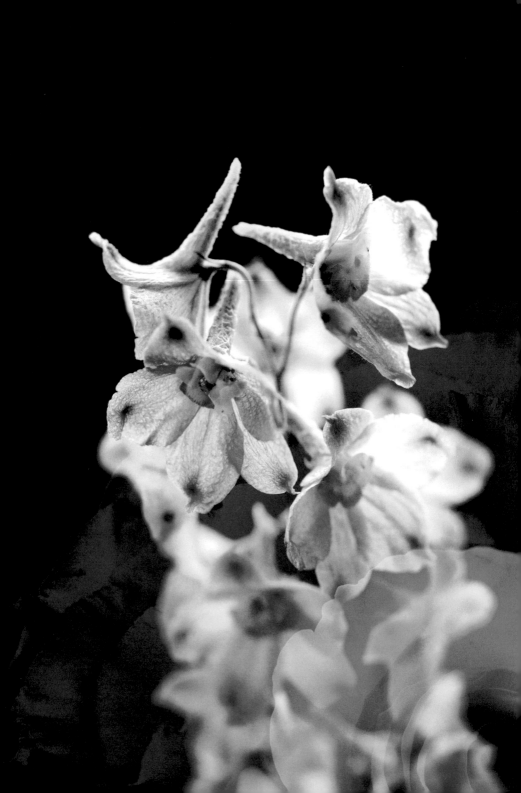

This record could not have been made without the support of all Kristin's "Strange Angels" and the following Sponsors: Michael Ashburne, Darrell Branch, Paul Bruneau, Francis Dutton, William Field, John Freeman, Beth Hill, Molly Cliff-Hilts, Hans Janowitz, Sean Murphy, Dan Weissman, Francois Wolmarans.

Kristin Hersh
"Crooked"
Produced by Kristin Hersh
Executive Producer - Sir Francis Dutton
Recorded & Mixed by Steve Rizzo
Mastered by Joe Gastwirt at Gastwirt Mastering, Oak Park, CA
Recorded from October 2007 through December 2009 at Stable Sound Studio, Portsmouth, RI, USA

All instruments on this recording are played by Kristin

All songs written by Kristin Hersh
Published by Yes Dear Music (BMI)
Administered by Bug Music, Strictly Confidential and Mushroom Music

KRISTIN HERSH

Kristin Hersh is a songwriter, guitarist and the founder of seminal art-rock band, Throwing Muses. Over the course of her two-decade career as a musician, she has released over twenty critically acclaimed albums, including nine solo albums and four with her newest project, 50FootWave.

She and her husband, Billy O'Connell, live with their four sons in Providence and New Orleans.

http://kristinhersh.com

Lisa Fletcher

Lisa Fletcher is from Atlanta, Georgia and currently lives in Los Angeles where she shoots pictures of people for a living. But she's a friend, first and foremost. Maybe I love her work so much because I love *her* so much. Because I know the real beauty of the person behind its creation. Lisa has a genuine gift for capturing moments with grace and a special kind of invisibility unique to particularly skilled photographers.

I asked her about these flower photos, which we begged her to take for the CASH Music project and her response was typically modest. "I think the only important thing about each one is that they were shot in natural light and that I tried hard not to mess with that light — how it hit the flowers."

Thank you, Fletch.

http://lisafletcherphoto.net

Jesse von Doom

Jesse von Doom is an artist. He's a designer and programmer too, but at the bottom of it all — and what is most special about him to me — is his ability to create real beauty and bring it to everyday applications. His sensitivity and ethos are powerful — especially when combined with his unparalleled passion and commitment. Suffice to say, he's one impressive dude.

I'm still not quite sure how I became lucky enough to know Jesse. We were introduced by chance 3 years ago and since that time he's contributed as much to my career development as anyone in my working life. I'm moved to know and to be a part of his beautiful family.

Jesse, you're invaluable. Thank you for making it all happen.

CASH Music

CASH Music is a nonprofit organization building open-source tools and services to benefit artists and music organizations. It's our belief that the need for technology should never get in the way of promotion, distribution, or support of great music.

http://cashmusic.org/

Creative Commons

Creative Commons is a nonprofit organization dedicated to making it easier for people to share and build upon the work of others, consistent with the rules of copyright. Creative Commons develops and stewards legal and technical infrastructure that makes sharing easy and legal in order to maximize the creative potential of digital networks.

http://support.creativecommons.org/

THE FRIDAY PROJECT
The Friday Project is an experimental imprint of HarperCollins Publishers in the UK. They publish everything from children's books to cookery, memoir to cutting-edge fiction, and always try to do so in a different and exciting way. They were one of the first publishers to offer complete books as free downloads and continue to do so.